To Amani
Who swam with
the Manatees in
the Florida Keys!
Love,
Carol & Will

MANATEE

PHOTOGRAPHS
By Rei Ohara

TEXT
By Akemi Hotta

CHRONICLE BOOKS
SAN FRANCISCO

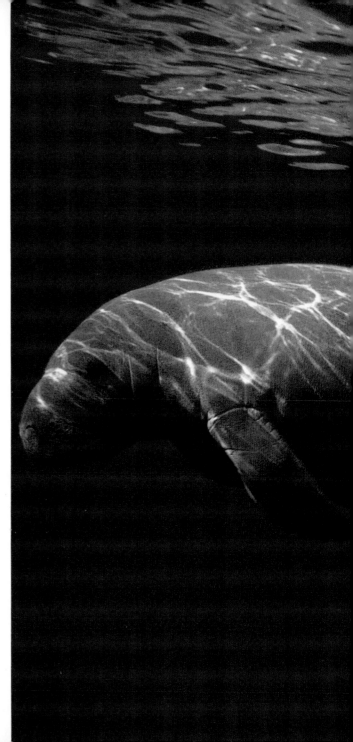

First published in the United States in 1998
by Chronicle Books LLC.

First published in Japan in 1996 by
Shichiken Publishing Co., Ltd.

Printed in Hong Kong.

ISBN 0-8118-1920-5

Library of Congress Cataloging-in-Publication Data available.

Cover Design: Michelle L. Benzer
Text Design: Michelle L. Benzer
Book Design: Makoto Tatebe and Miki Sadakane
Cover Photograph: Rei Ohara

Distributed in Canada by
Raincoast Books
9050 Shaughnessy Street
Vancouver, B.C. V6P 6E5

10 9 8 7 6 5 4 3 2

Chronicle Books LLC
85 Second Street
San Francisco, California 94105

www.chroniclebooks.com

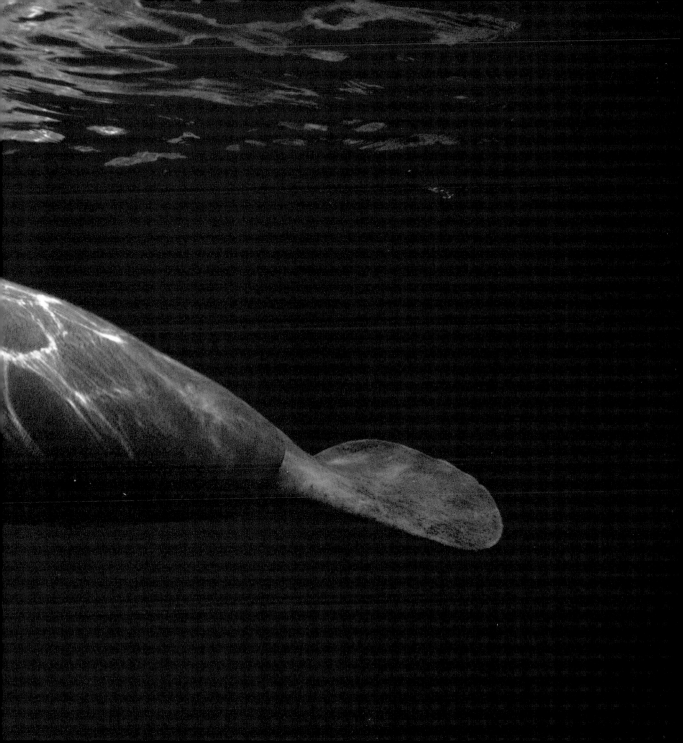

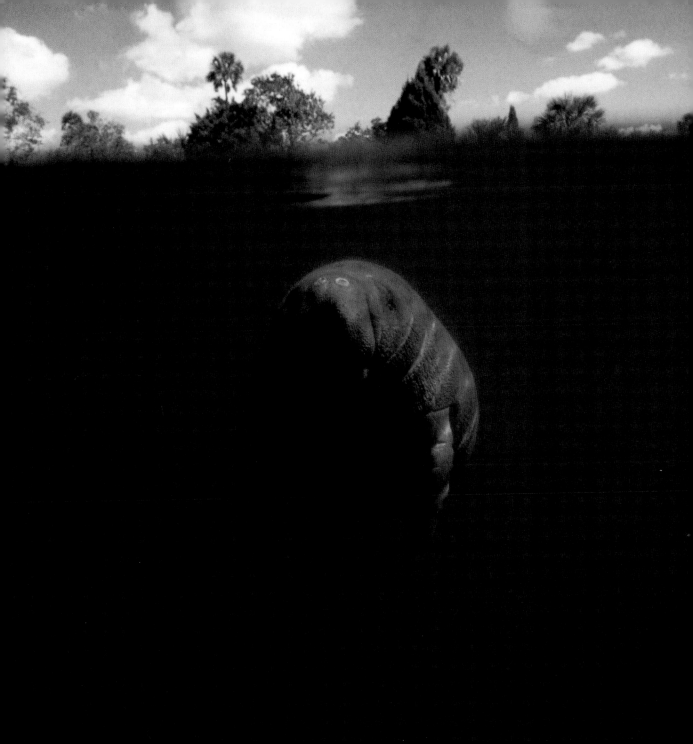

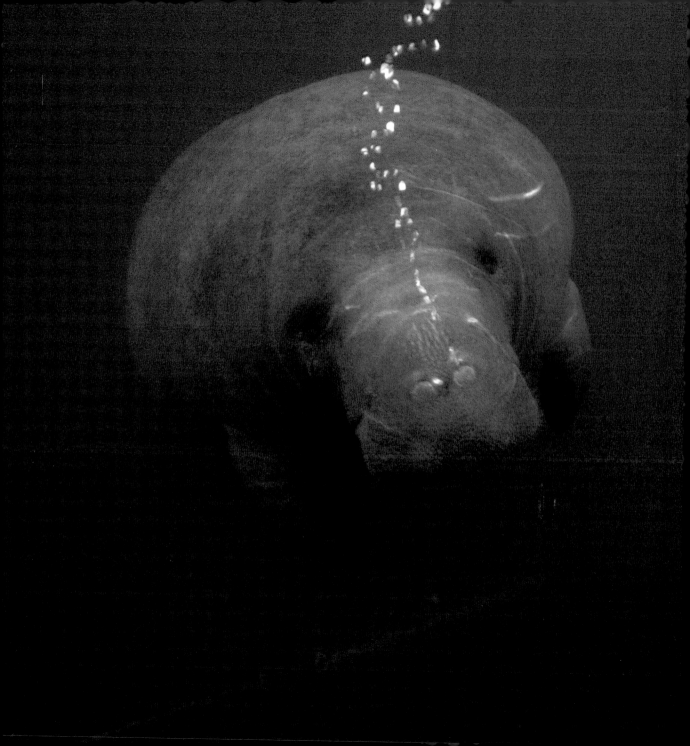

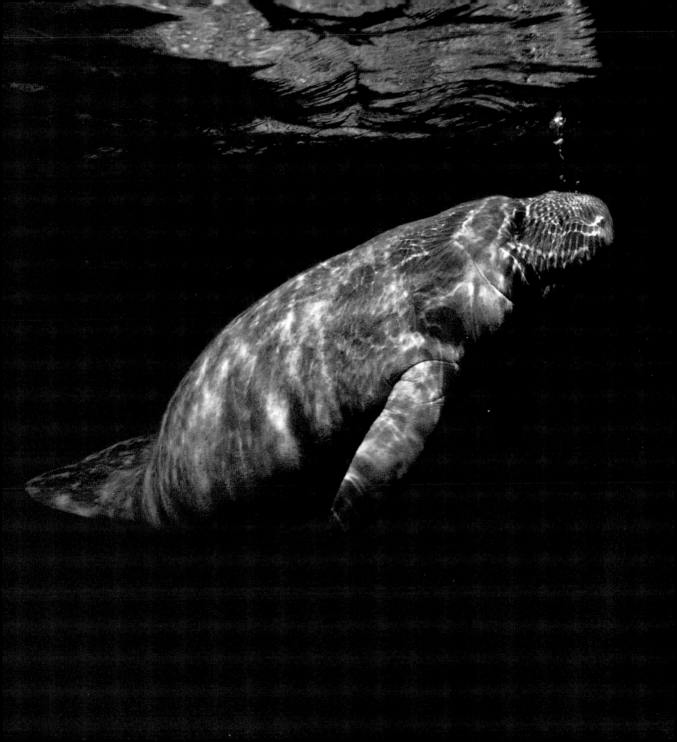

Manatees have vestigial, or remnant, fingernails on the end of their flippers. These are believed to be the last remaining physical characteristic from the days when they were land animals.

A doting mother manatee
and her calf. The most complex
manatee behavior is between
mother and calf. Calves usually
stay with their mothers for two
years, learning about feeding
areas, migratory patterns, and
warm water refuges.

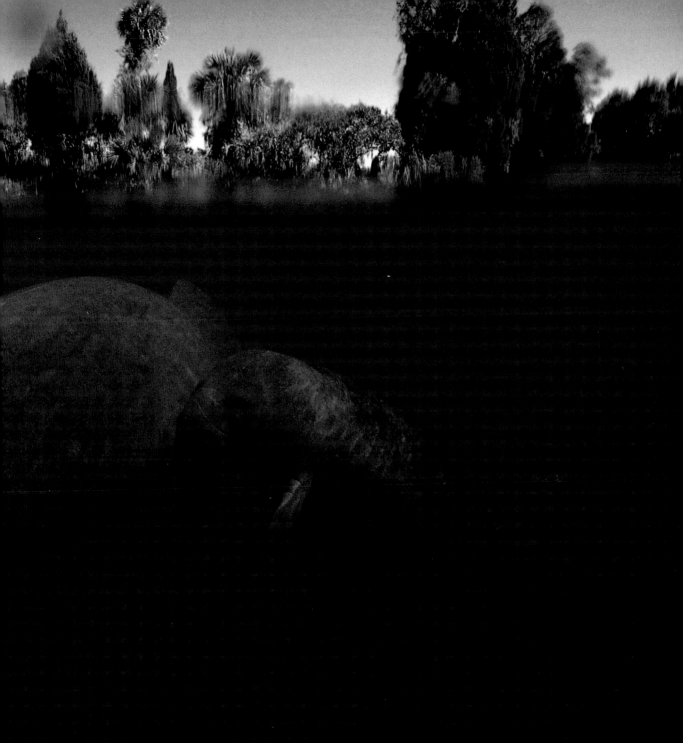

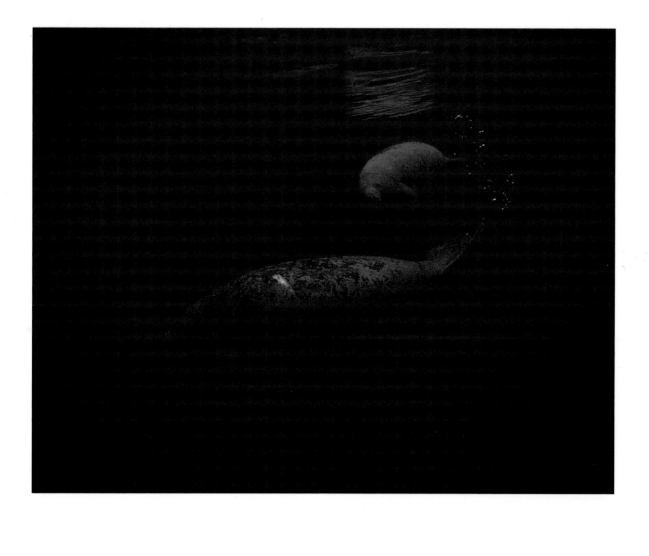

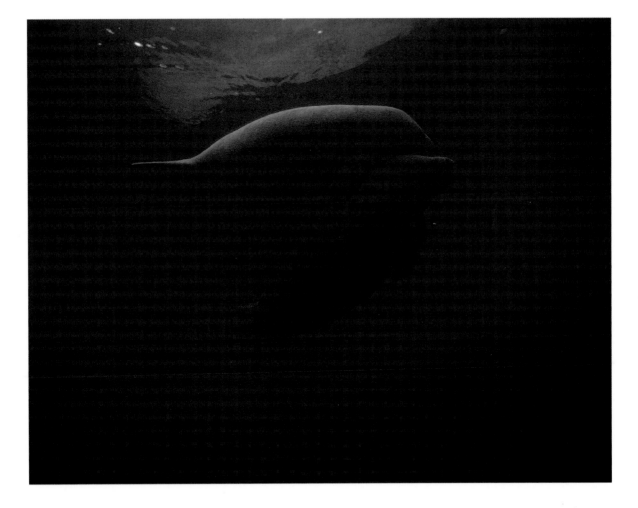

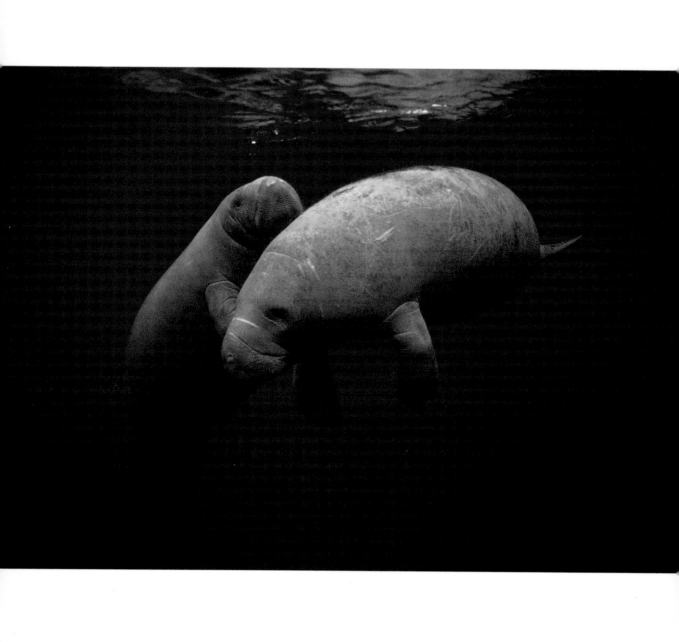

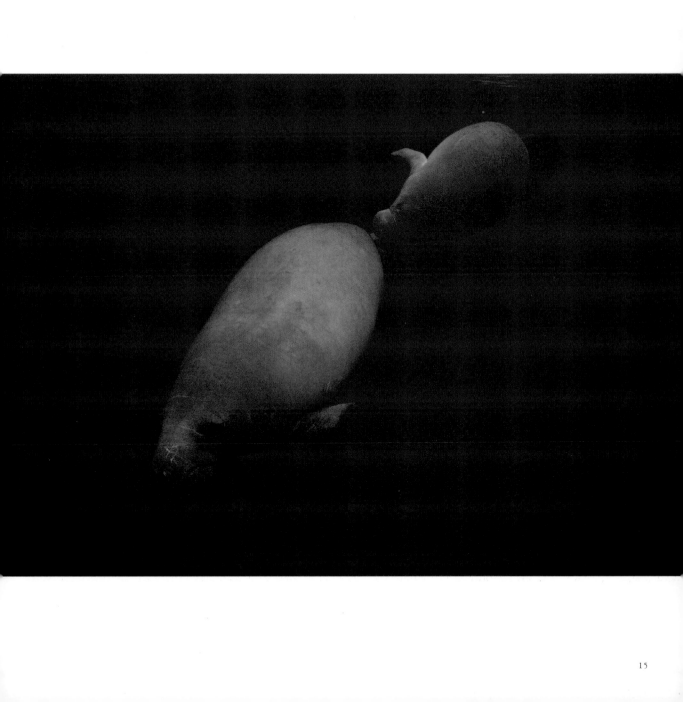

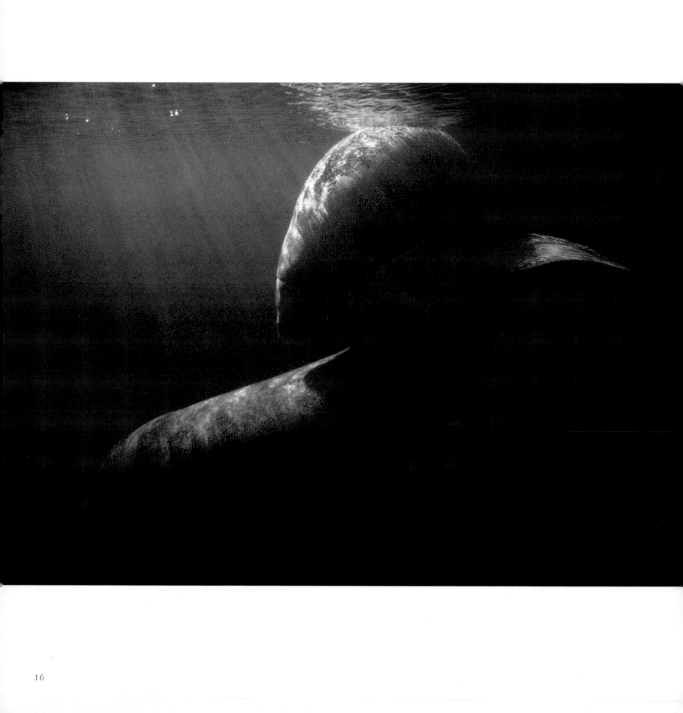

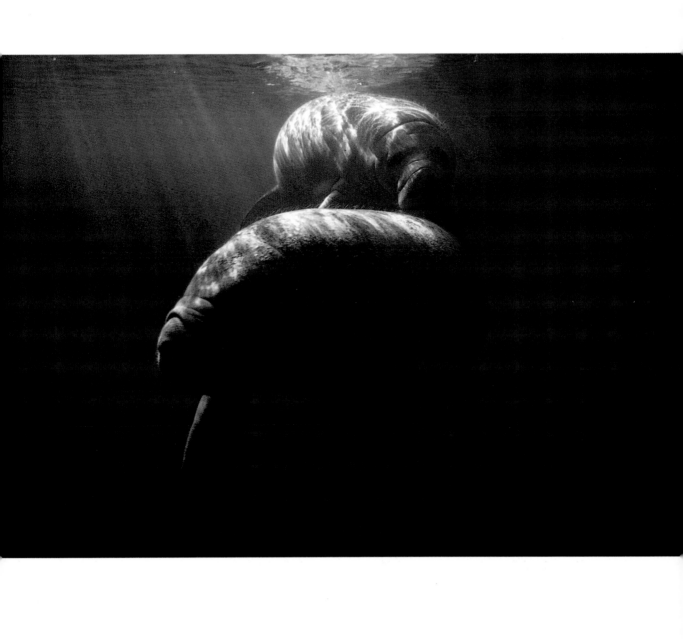

A nursing calf. The mother's nipple is located just behind her flipper, in her "armpit." A mother manatee will often roll over on her side to make it easier for her calf to nurse.

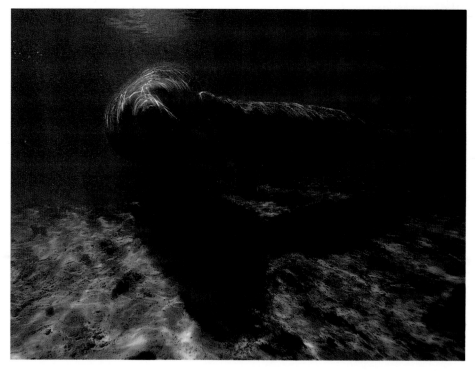

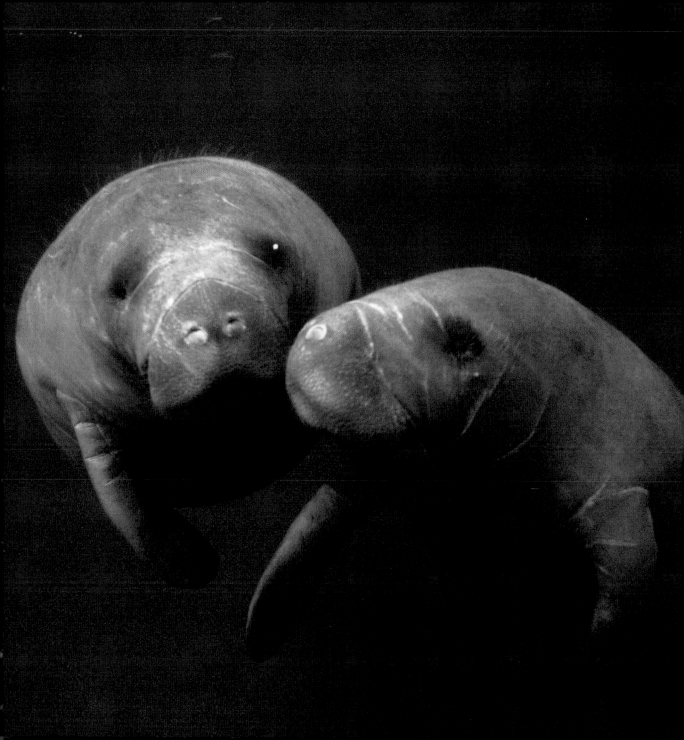

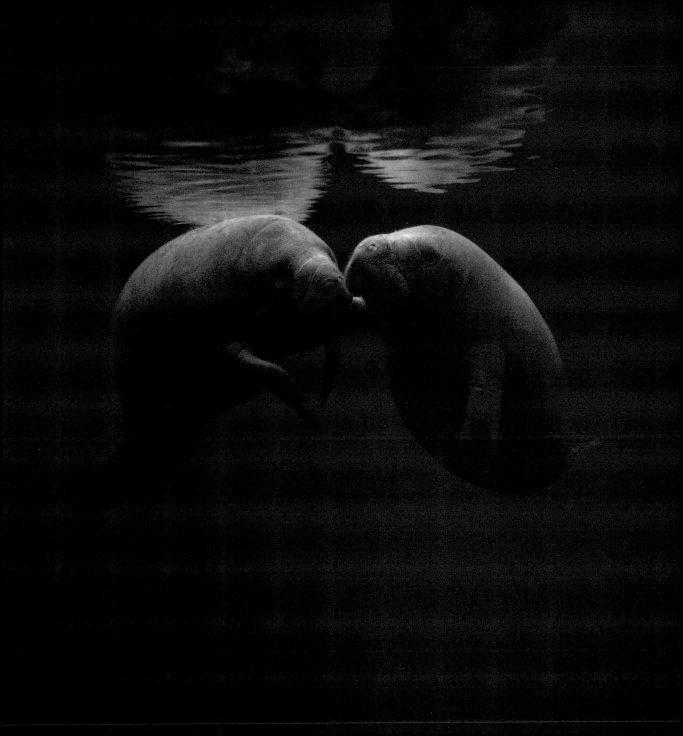

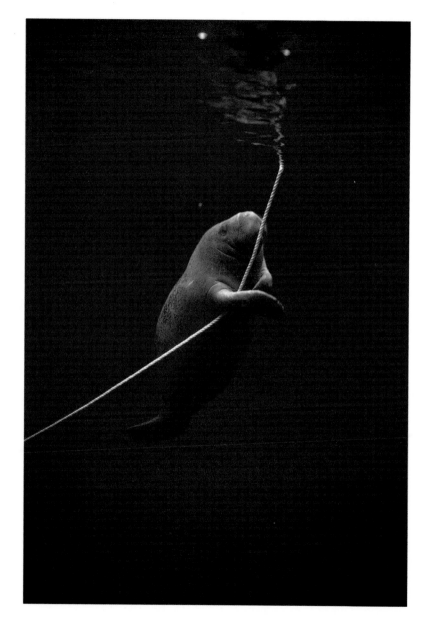

This curious manatee

is investigating an anchor line.

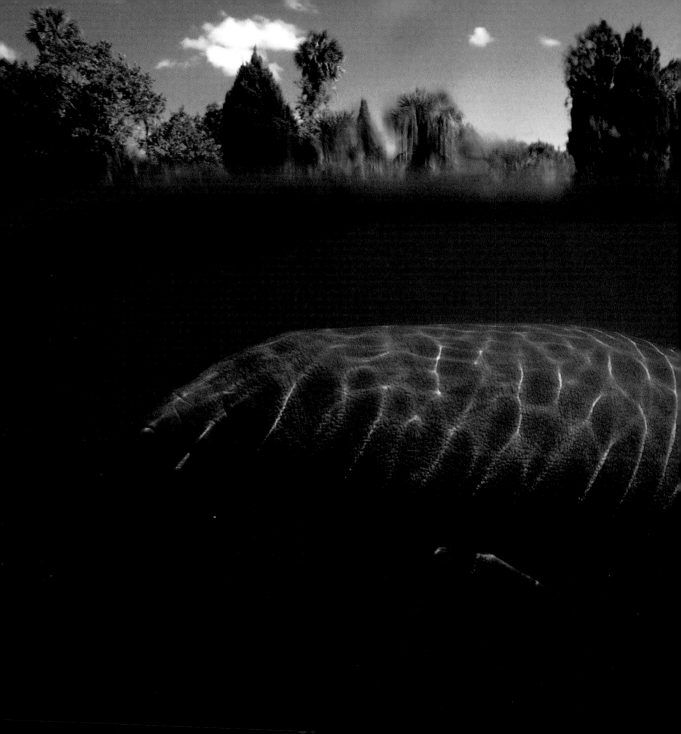

The two manatees at the far right are surfacing to take a breath. When active, manatees breathe every three to five minutes.

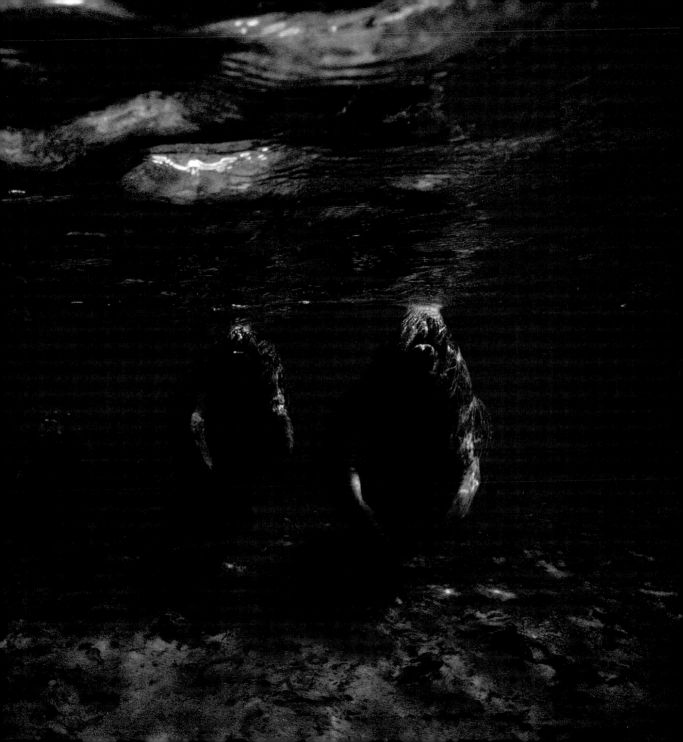

A manatee taking a breath. When submerged, the manatee's nostrils are covered by flaps.

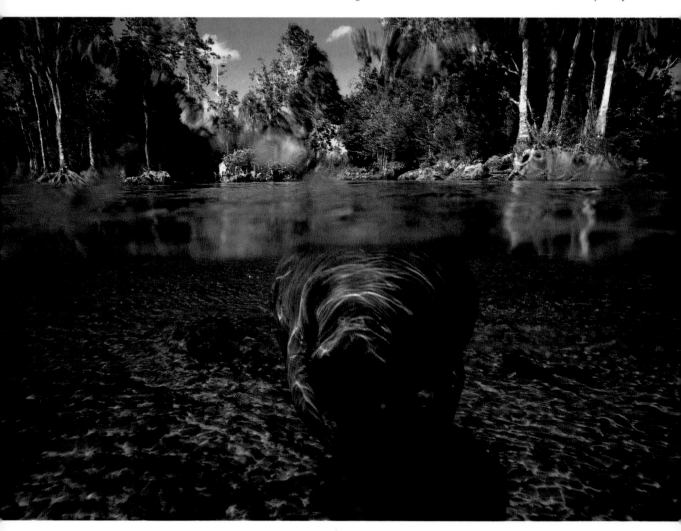

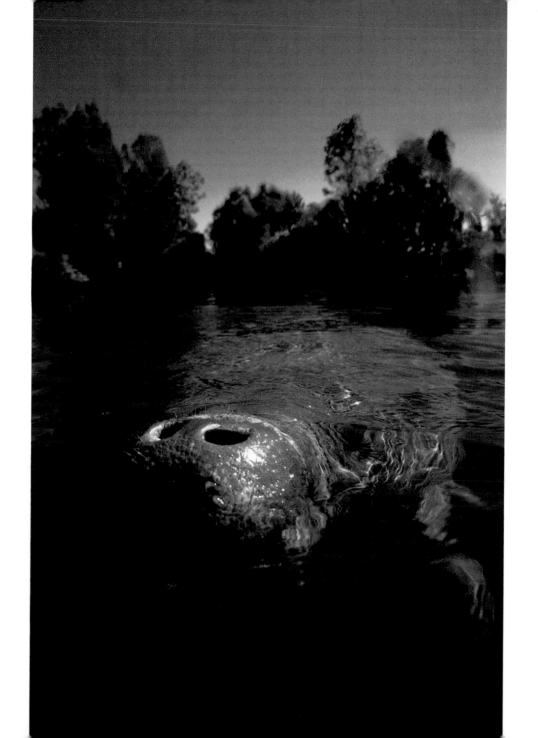

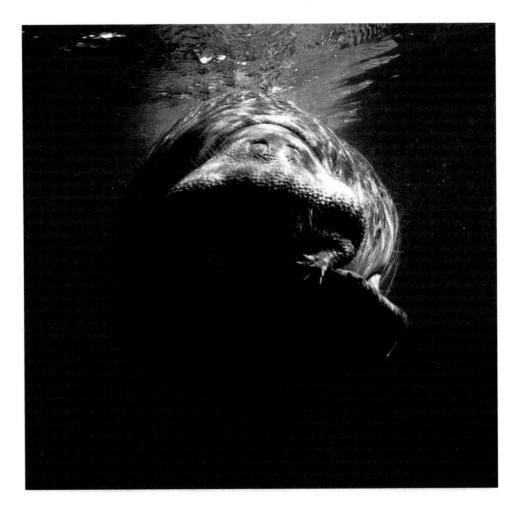

These manatees seem to be mugging for the photographer, but they are probably using their flippers to dislodge unswallowed plant material.

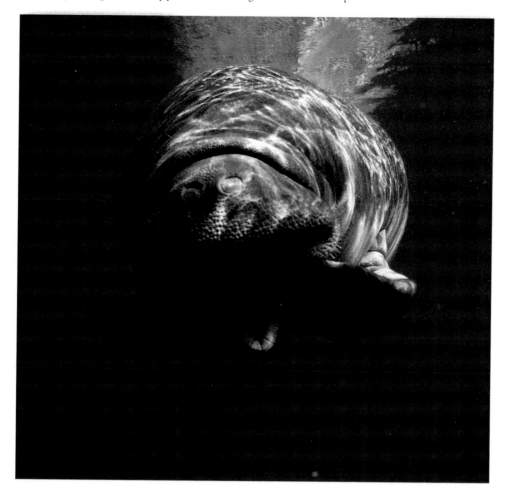

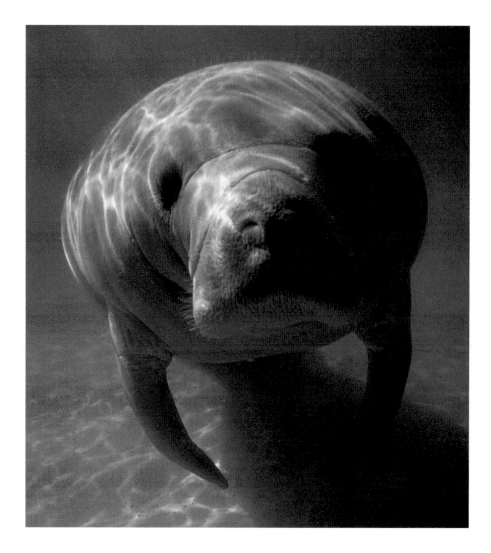

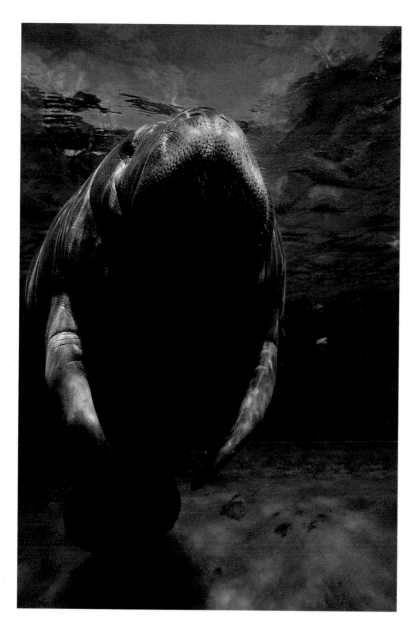

Although manatees
are shy and initially wary of humans, they are also curious and may eventually approach a diver. They love to have their backs scratched. The Endangered Species Act forbids divers from touching a manatee unless it touches the diver first.

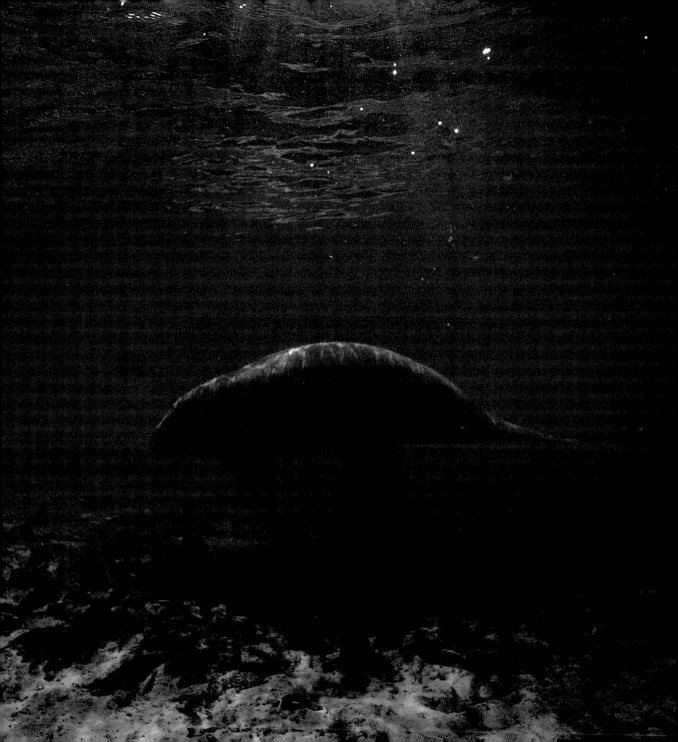

Manatees spend a lot of time resting. Here, a school of fish has taken refuge under a dozing manatee.

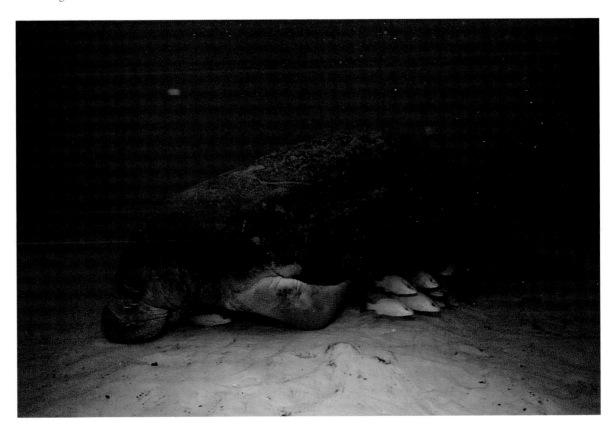

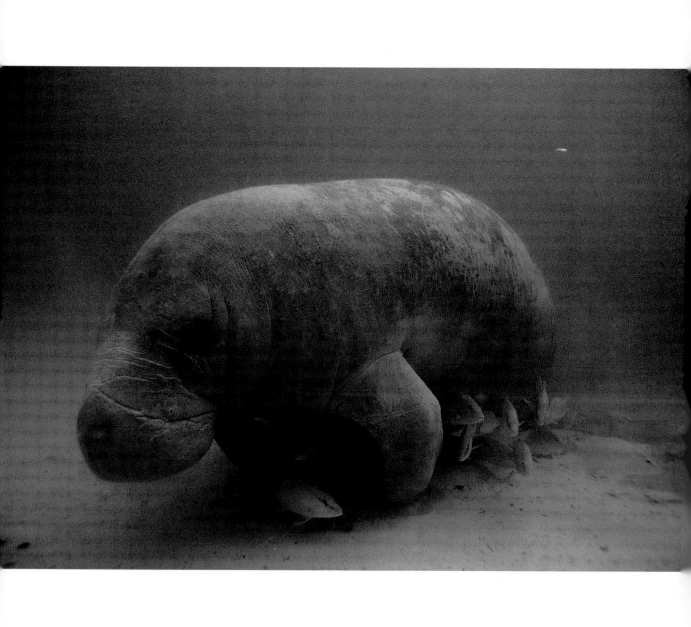

The telltale bubbles of intestinal gas caused by the vegetation that manatees eat.

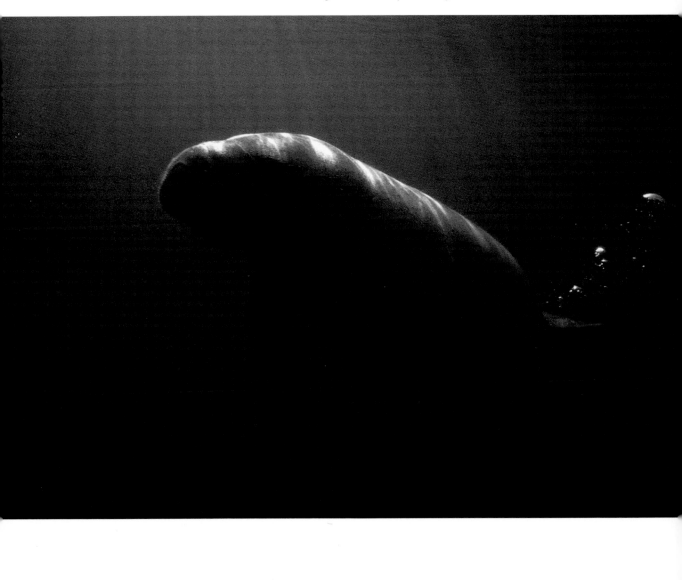

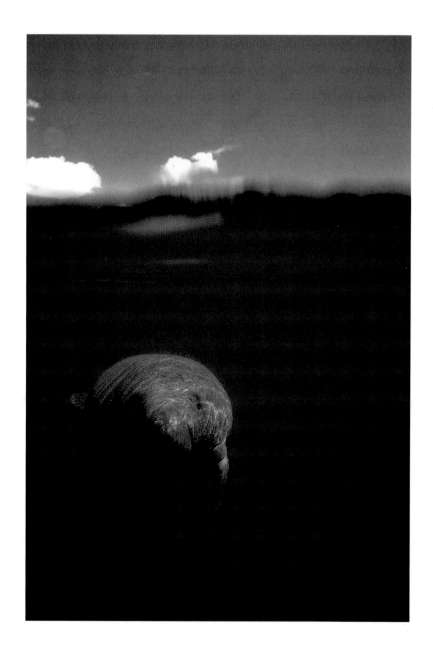

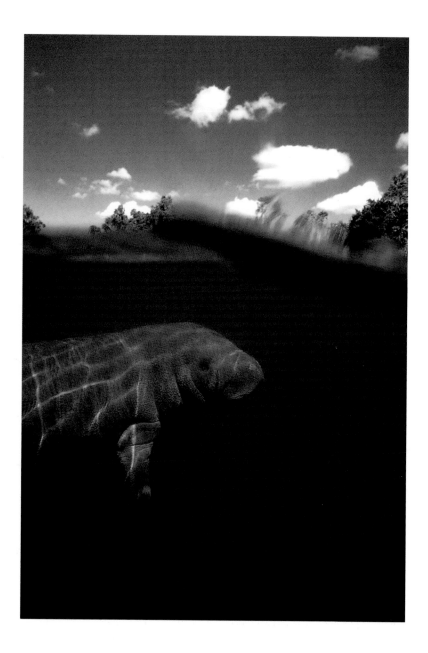

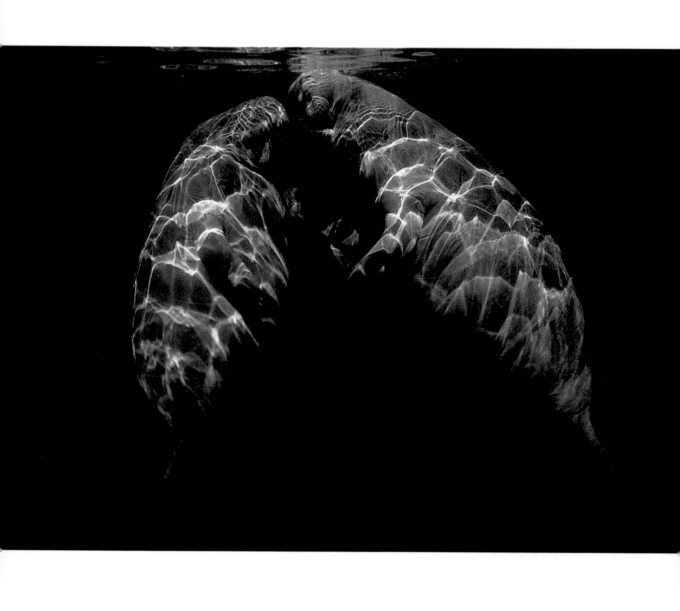

Manatees enjoy nuzzling, and researchers believe that touching is an important part of manatee communication.

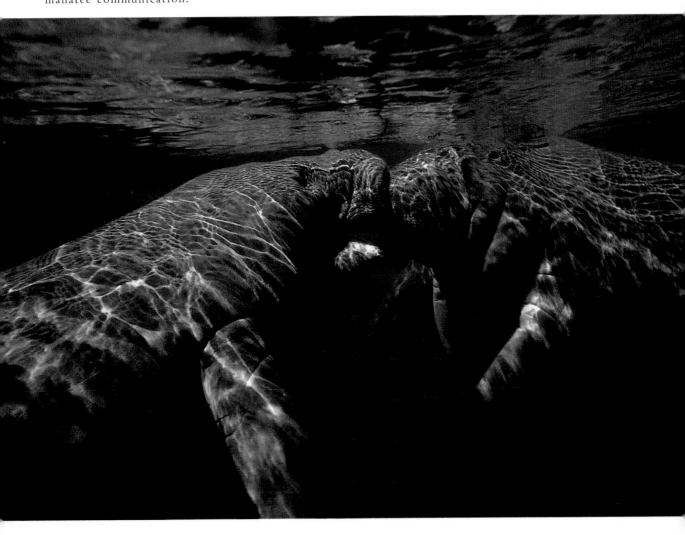

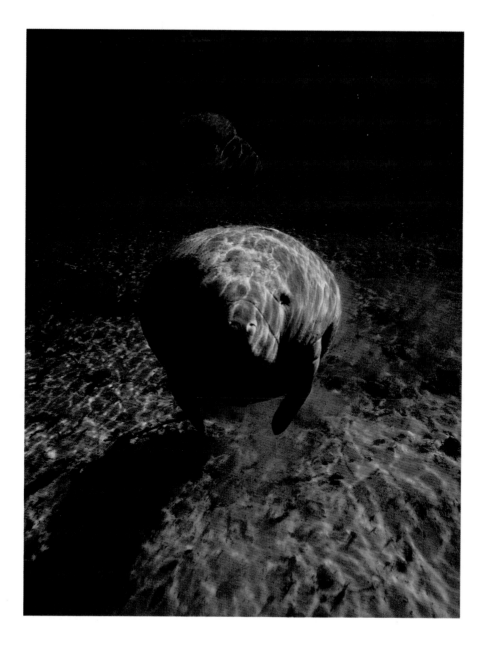

Although their eyes are small, manatees have a keen sense of sight. Their ears are located just behind their eyes, but are very small and difficult to see. In addition to communicating by touch, manatees make noises that have been described as squeals, chirps, and whistles. Much about this form of communication remains a mystery, however.

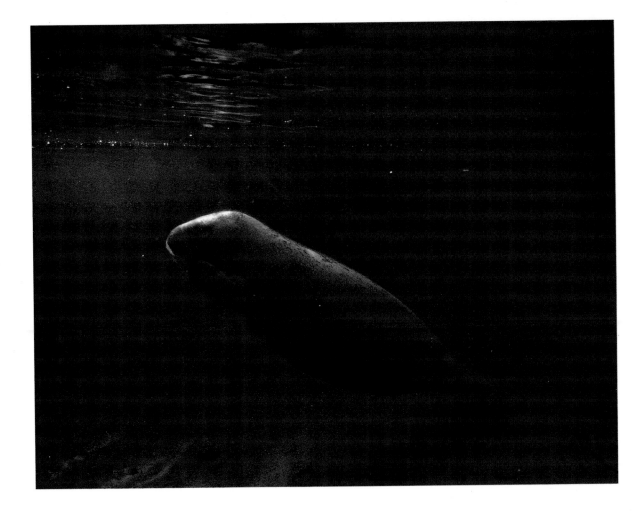

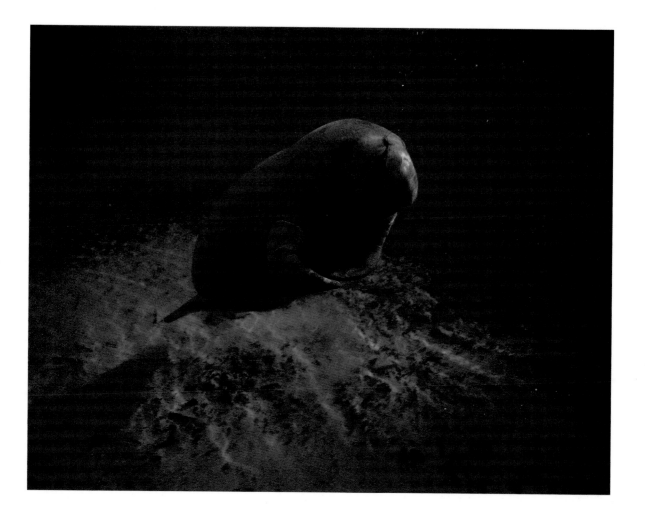

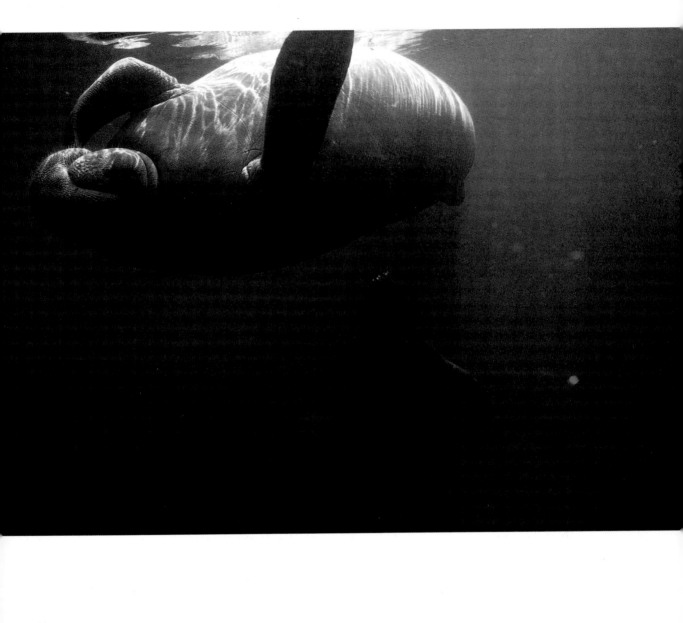

Manatees like to play. These two seem to be playing a game of tag.

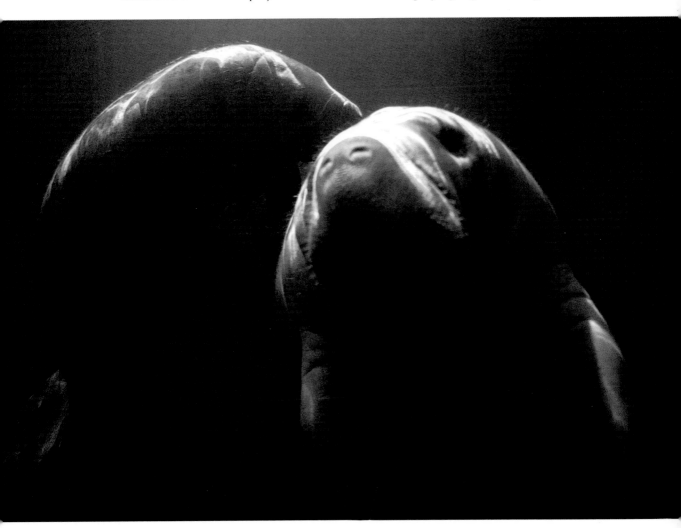

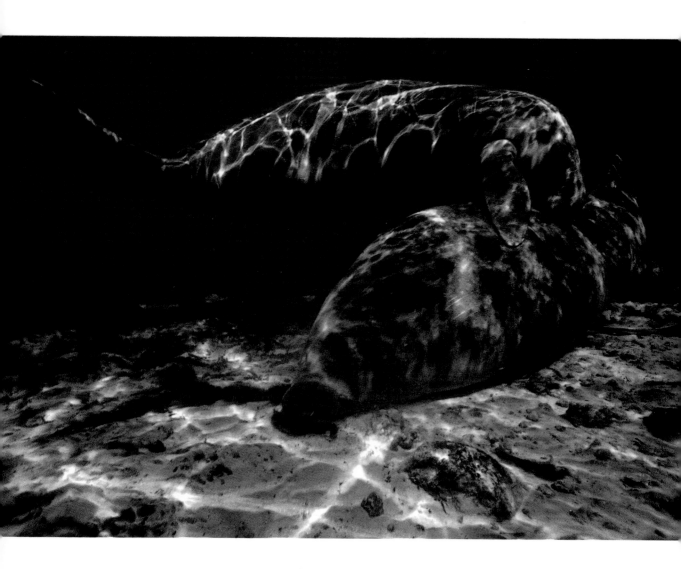

Algae will attach itself to manatees' backs while they sleep. They continually slough off their outer layer of skin; perhaps this is why the algae does not seem to bother them.

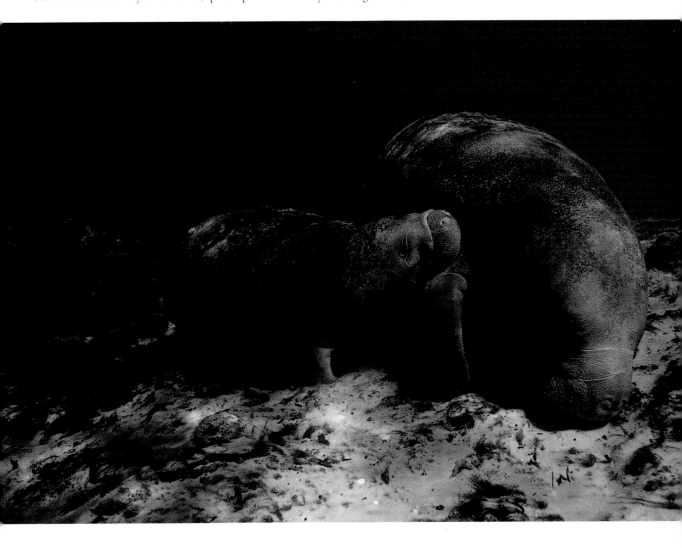

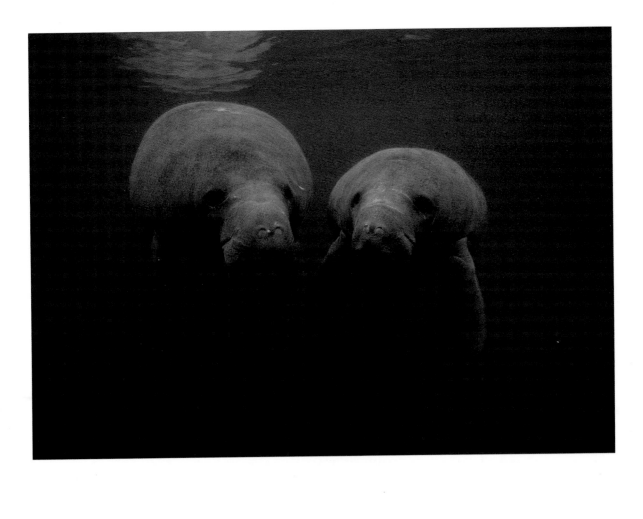

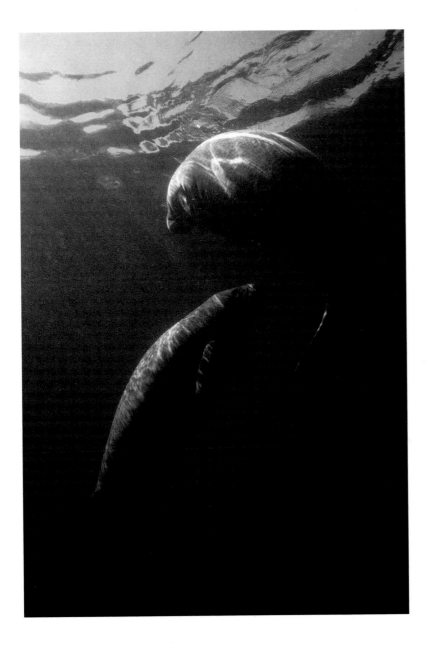

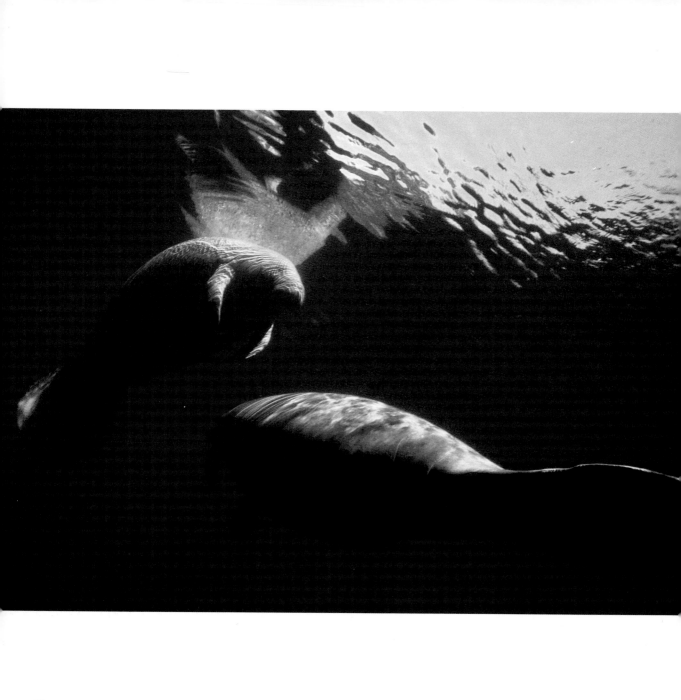

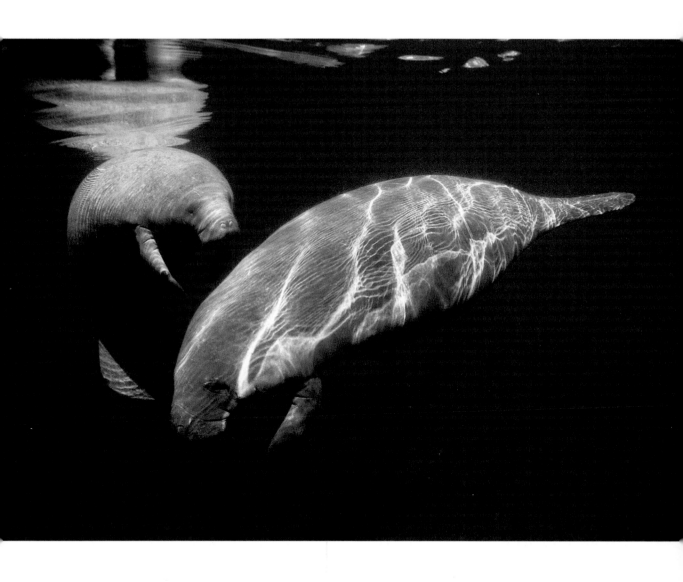

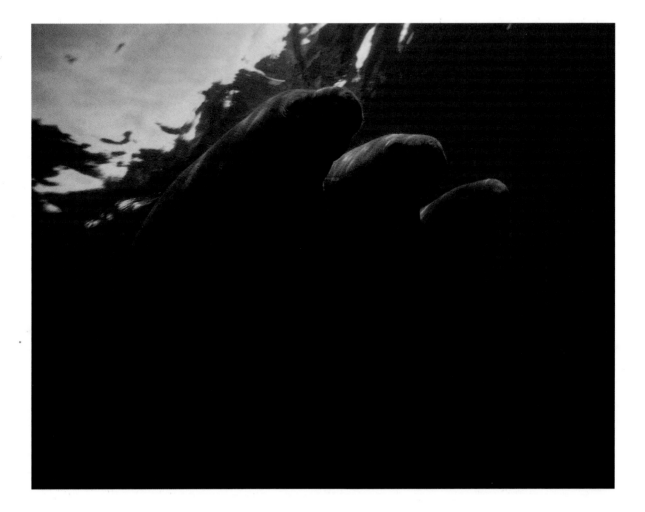

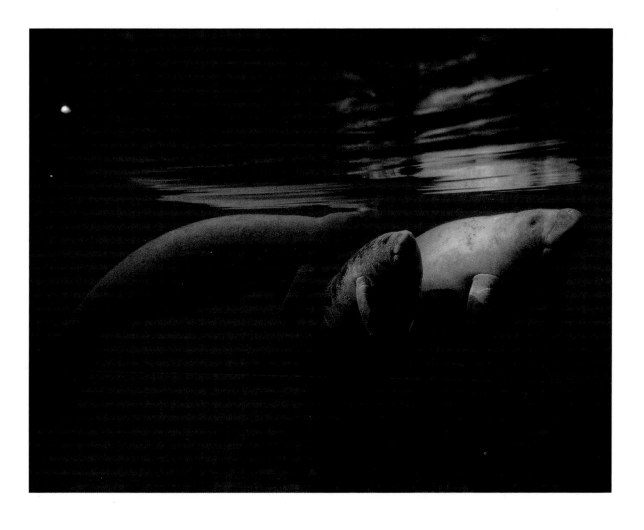

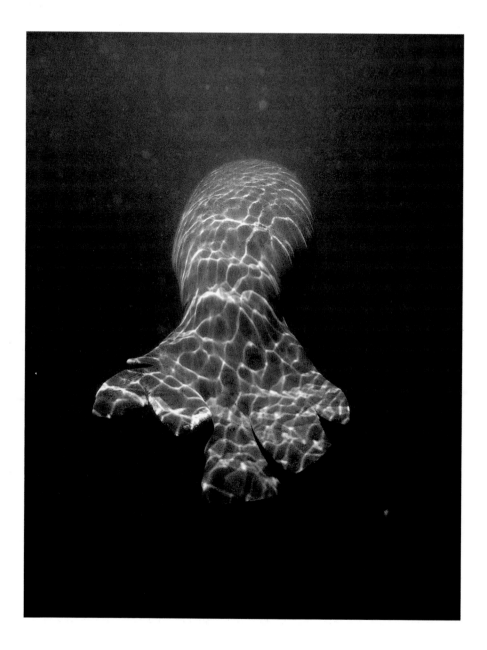

This adult manatee's tail has several severe cuts from a boat propeller.

Ready to play, this manatee is joyfully doing a barrel roll.

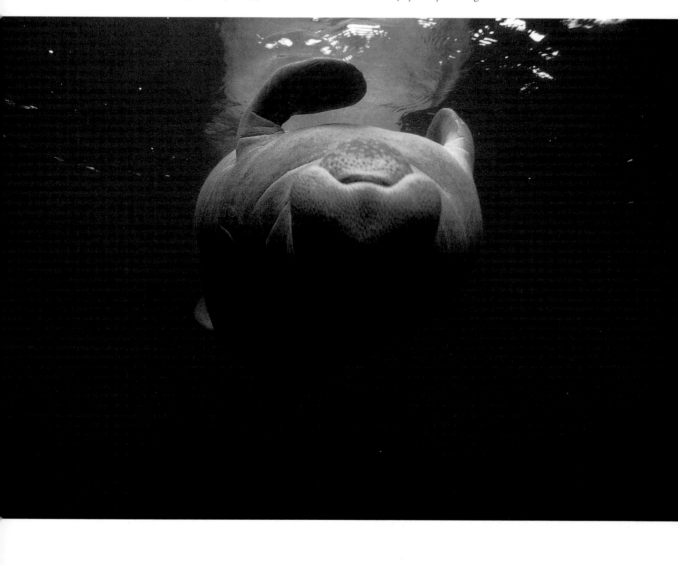

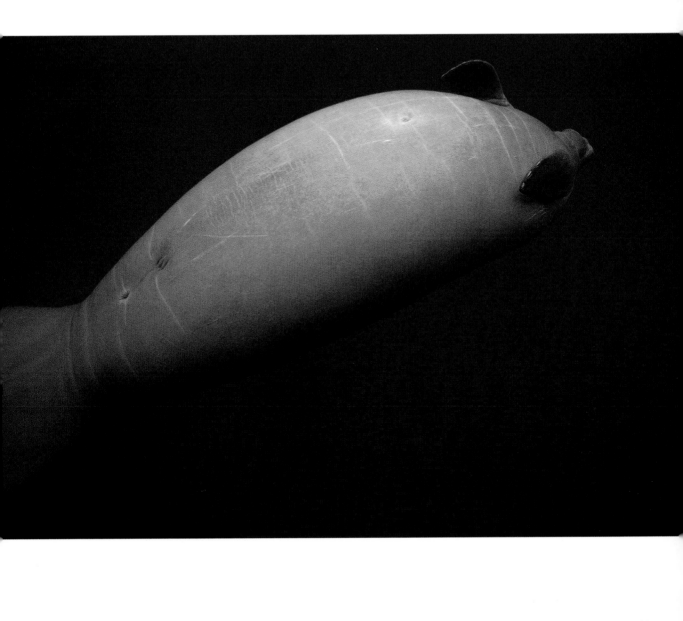

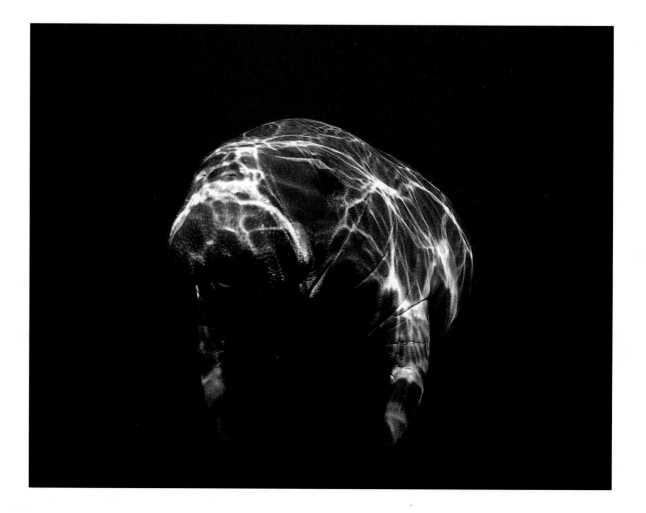

Moonlight shining on a manatee.

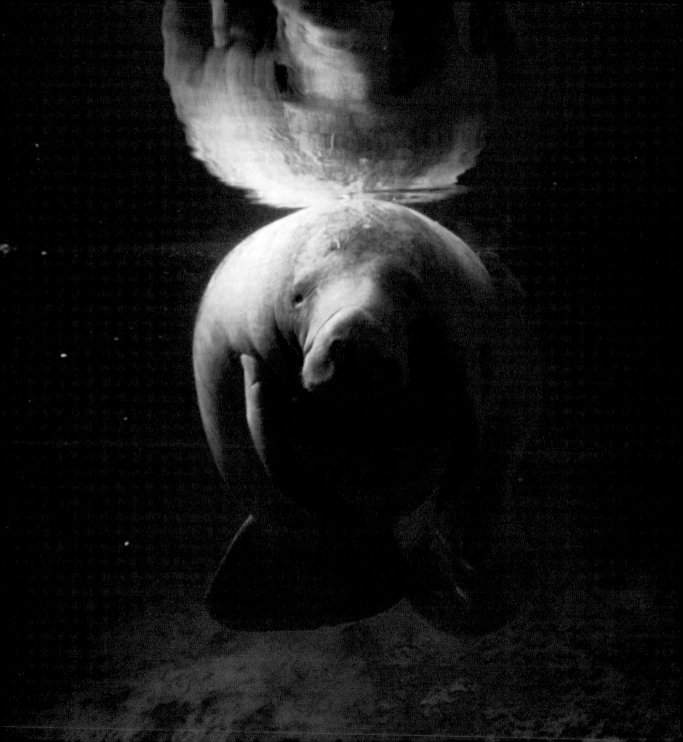

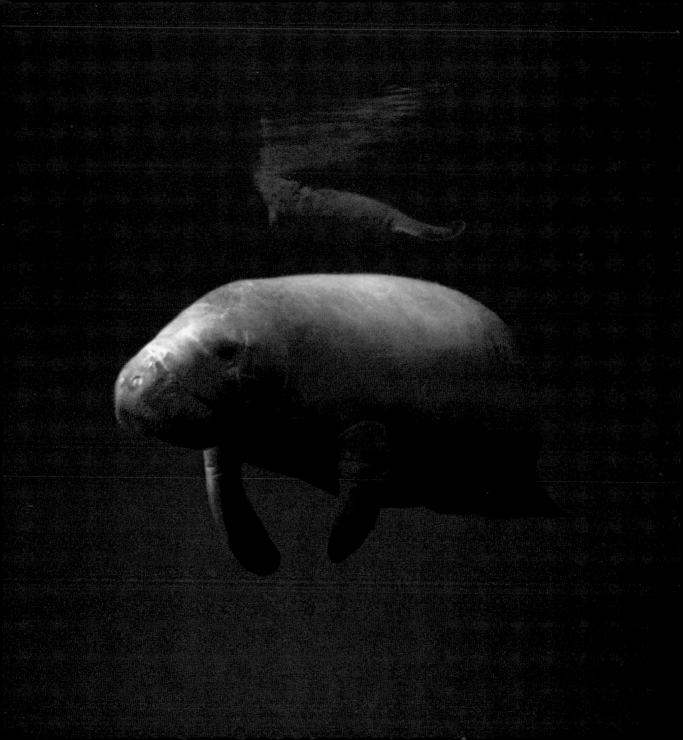

Although manatees are solitary creatures, in the winter months they often congregate in groups in warmer waters.

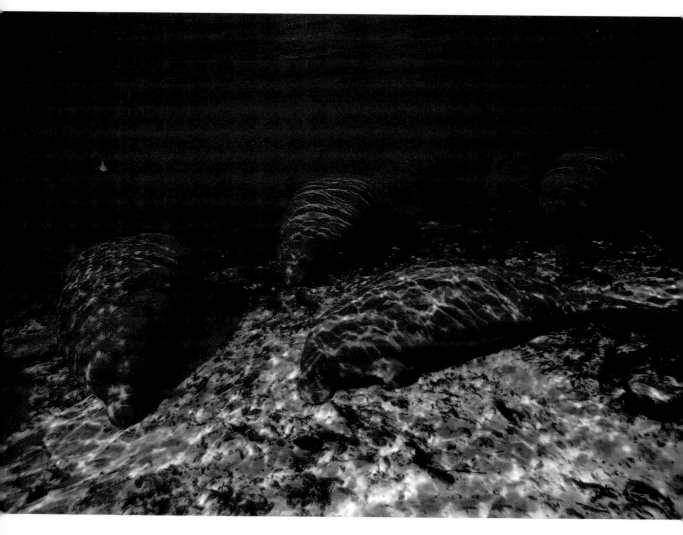

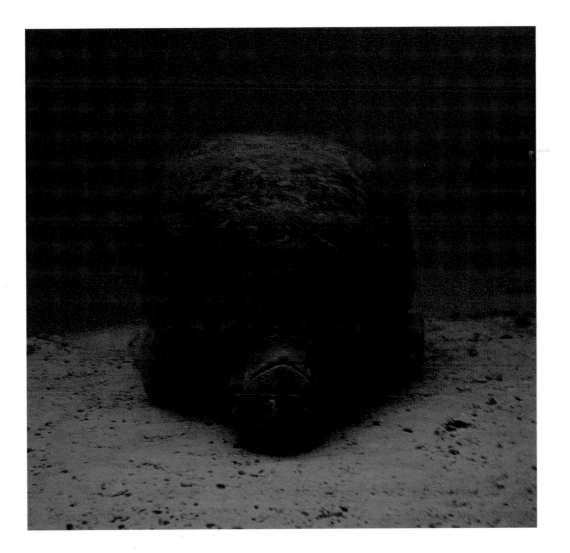

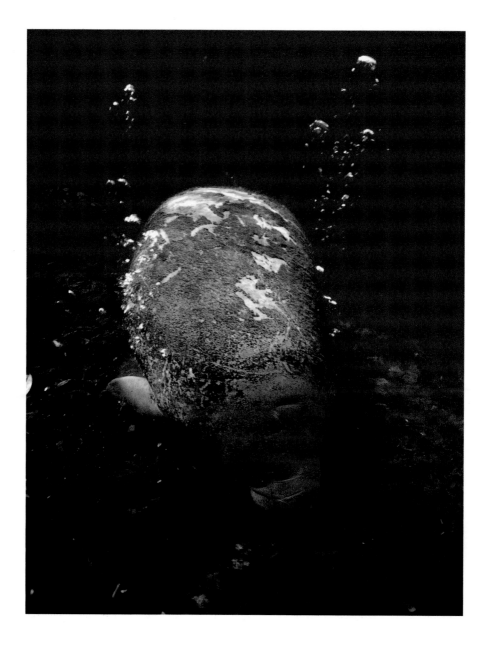

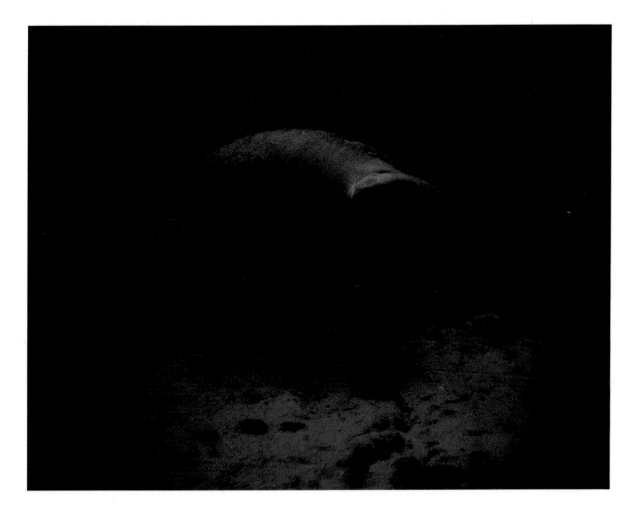

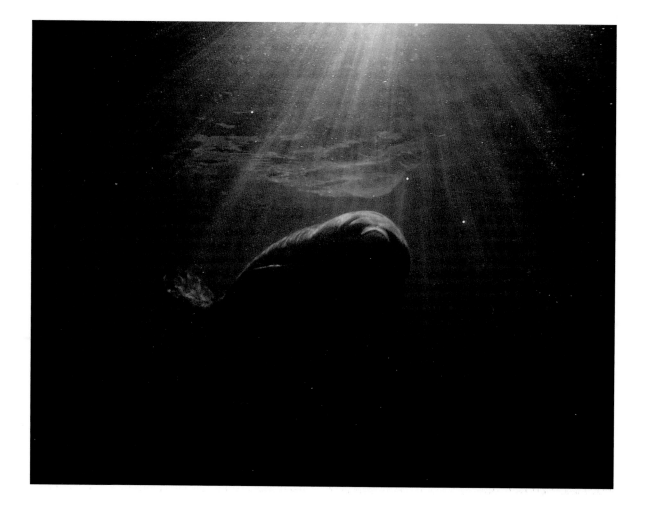

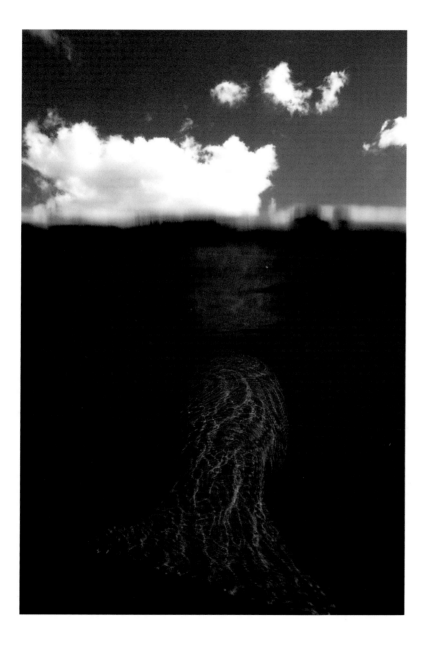

Manatee tails are paddle-shaped, like a beaver's tail. Manatees can swim as fast as fifteen miles per hour, although their usual speed is around two to three miles per hour.

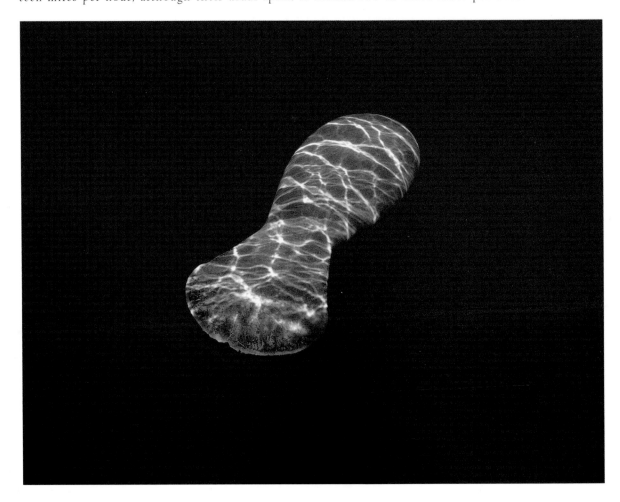

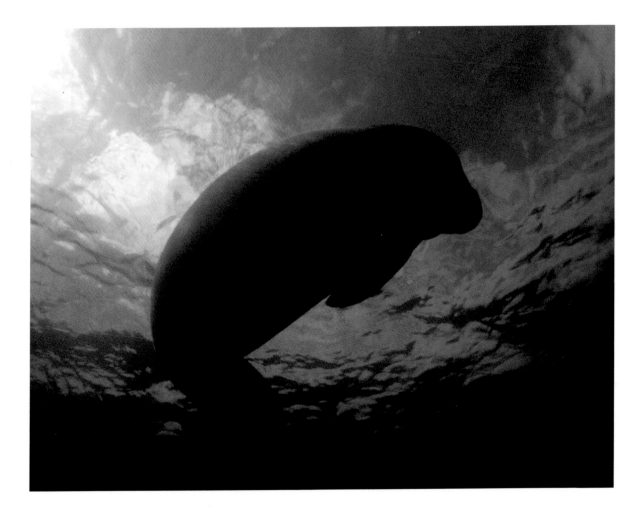

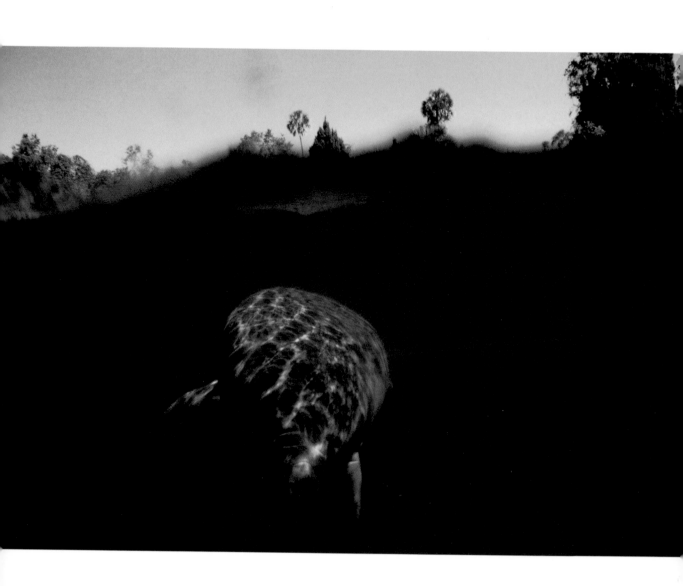

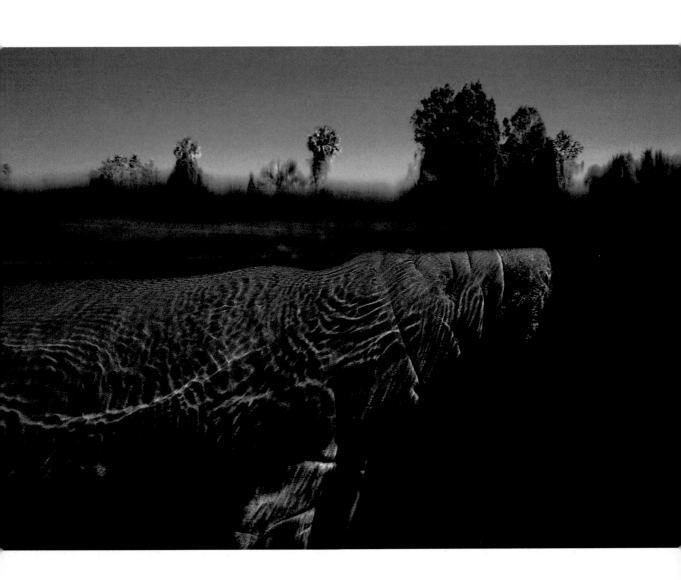

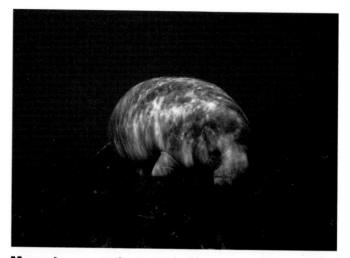

Manatees eat vegetation on the river bottom or floating vegetation. The manatee above is using its mouth like a vacuum, ingesting vegetation from the river bottom. Opposite, a manatee uses its flippers to guide food into its mouth. Either method works! Manatees eat up to two hundred pounds of food a day.

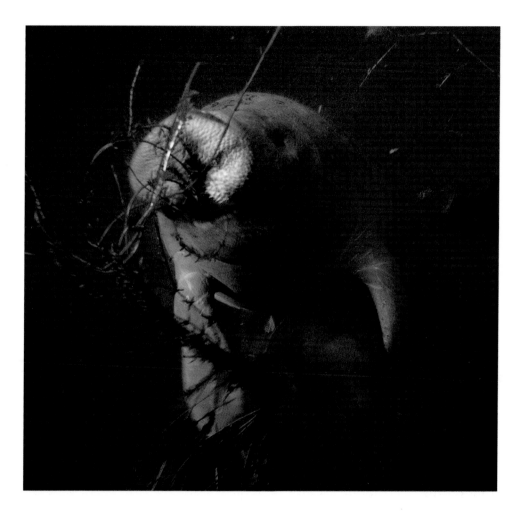

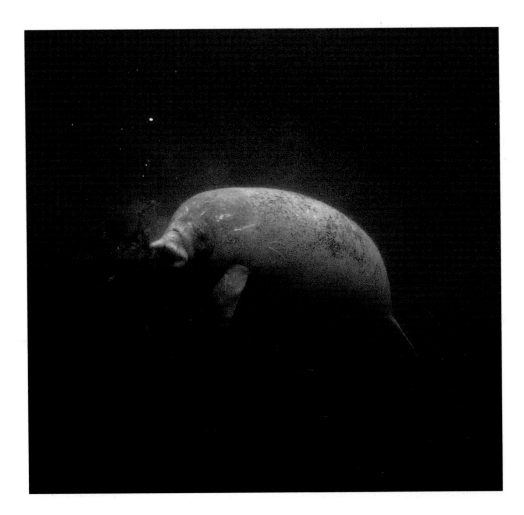

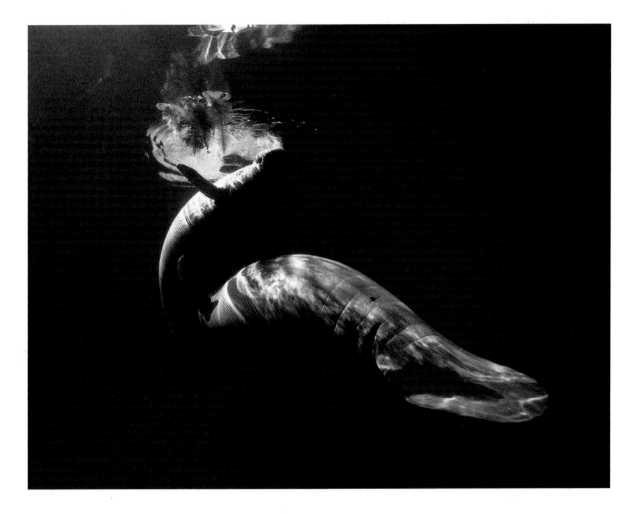

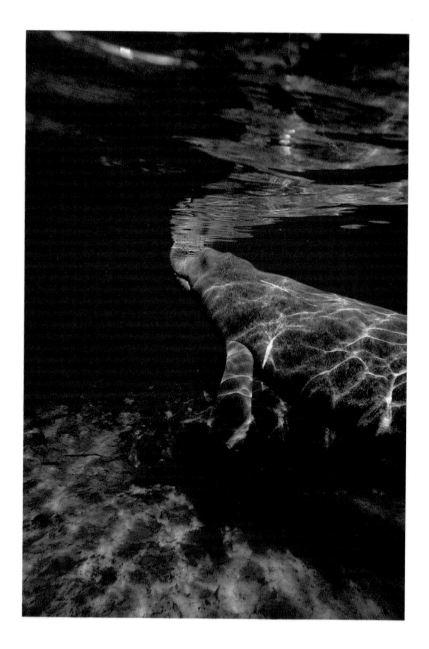

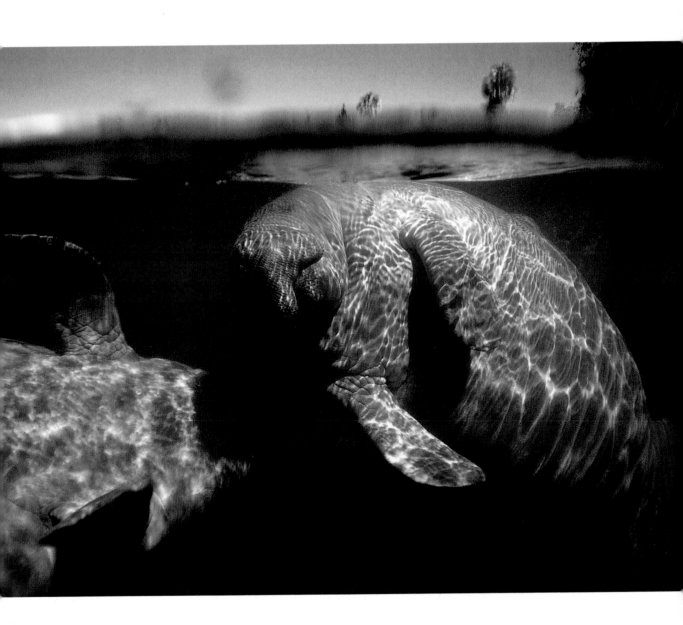

opposite: A mother and a calf swimming together. Calves always swim parallel to their mothers, just behind her flipper.

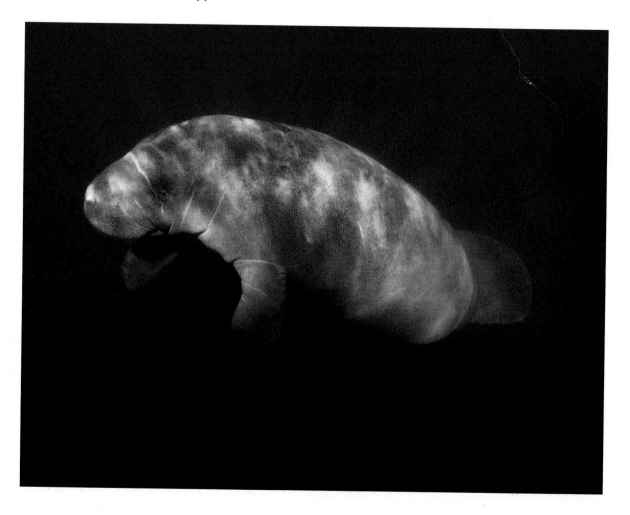

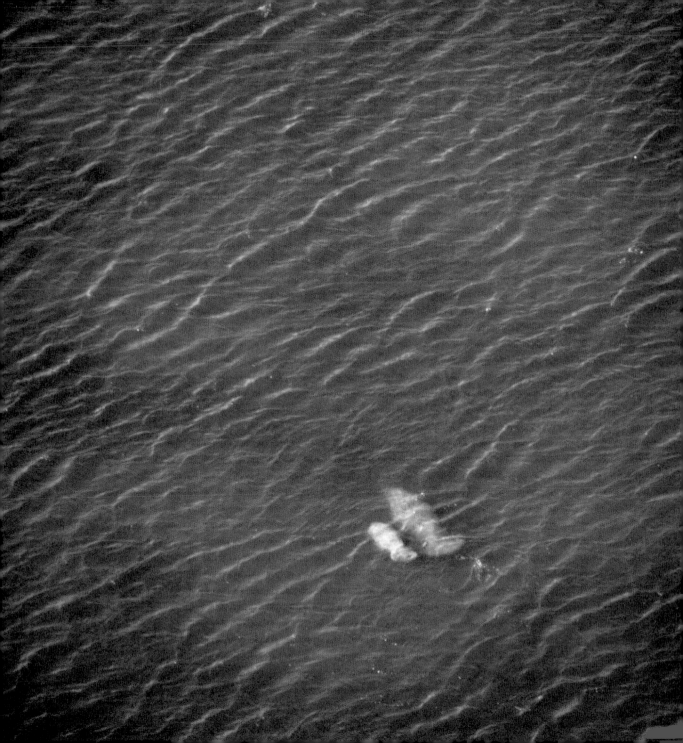

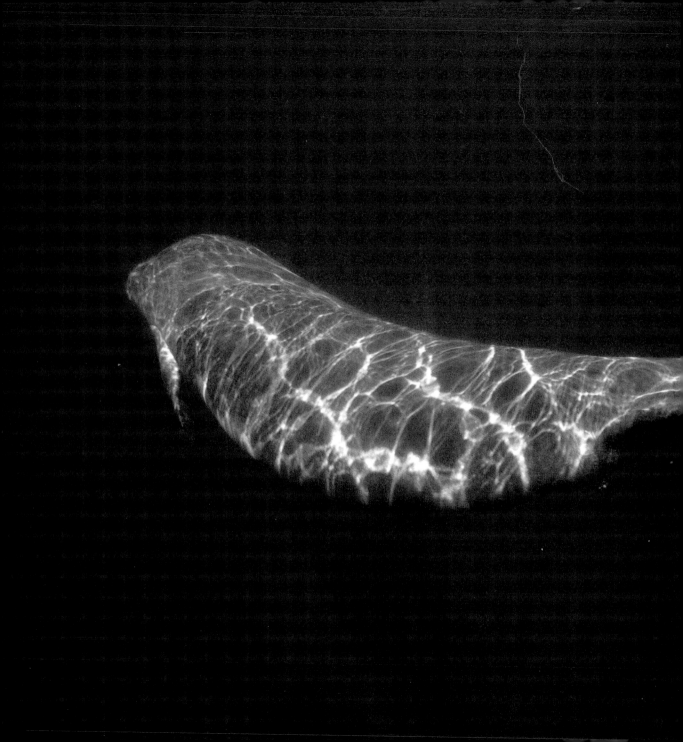

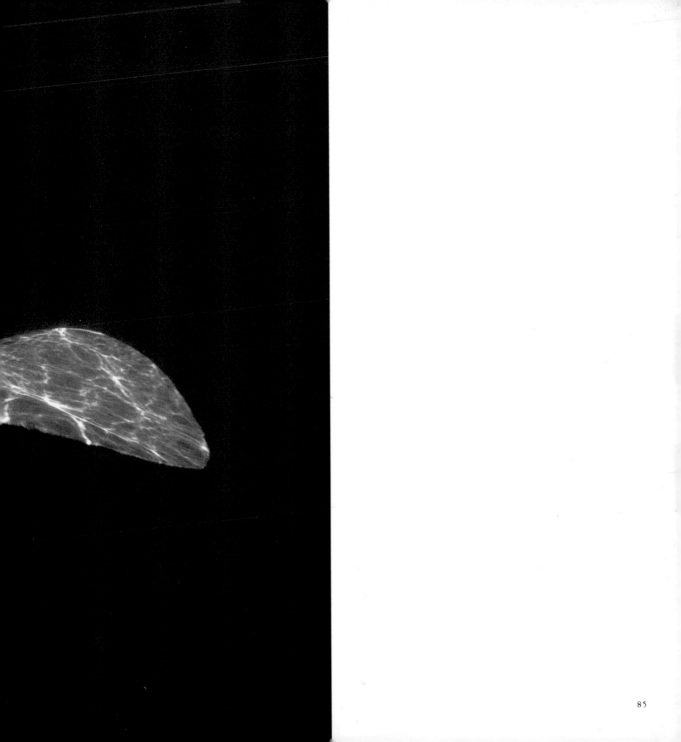

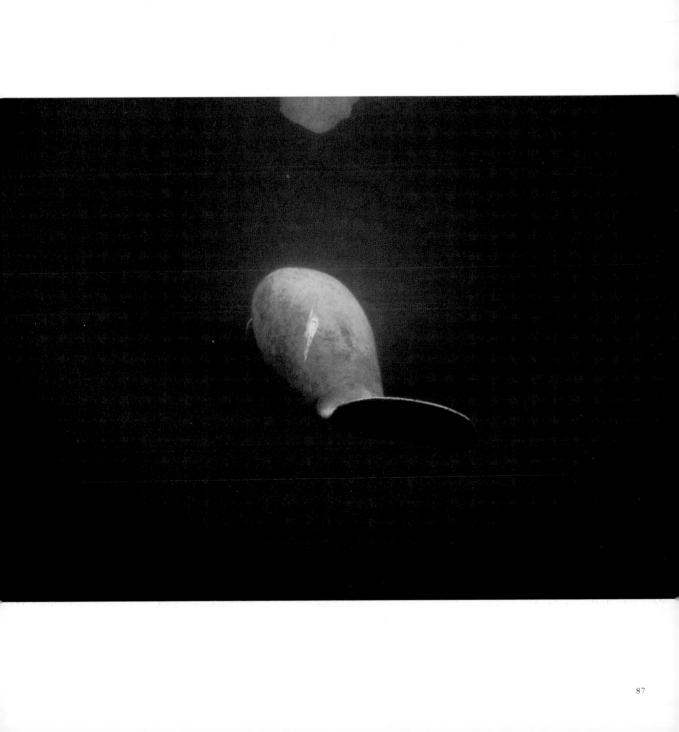

About the Manatee

Manatees, like whales, dolphins, walruses, and seals, are marine mammals. Stately and ponderous, these strange looking creatures are believed to be distantly related to the elephant. Manatees are members of the order Sirenia, which consists of the West Indian manatee, the West African manatee, the Amazonian manatee, the dugong, and the Steller sea cow (now extinct). Hundreds of years ago, sailors mistook manatees for mermaids, and the name of their order, Sirenia, has its roots in the mythical sirens, the bewitching creatures who tried to lure the ancient Greek hero Odysseus and his crew onto jagged rocks.

Fifty or sixty million years ago the manatee's ancestors fled the land and took up residence in the seas. Much about manatee behavior remains a mystery because manatees

are solitary and reclusive creatures. Like whales, they earned the name "gentle giant." No one knows for sure how long they live, but they are known to live upwards of fifty years. They are not territorial, nor are they aggressive. Manatees live in warm tropical and subtropical waters and as their names imply can be found in West Africa, the Amazon, the Caribbean, northeastern South America, and Florida. This book looks at the Florida manatee, a subspecies of the West Indian manatee. The Florida manatee's primary range on the Atlantic coast is from the St. Johns River in northeastern Florida southward to Miami. On the Gulf Coast, Florida manatees congregate in the waters of the Everglades National Park and up to the Suwannee River in the summer. In the cold winter months manatees migrate to Florida's warmer waters, such as the Crystal River or Blue Spring State Park on the St. Johns River.

Manatees are oddly shaped.

Their large bodies are sausage-like and their tails are rounded and paddle-shaped, like a beaver's tail. They have two pectoral flippers,

and each flipper has several vestigial fingernails, believed to be remnants from the days when they were land creatures. They use their tail to propel themselves forward and their flippers to control direction. The manatee grows to about twelve feet long and weighs 1,200 pounds on average, although it can weigh up to 3,500 pounds. Despite their large size, they swim with graceful ease. Their well-developed eyes are very small and located on the sides of the head; their ears, located a short distance behind their eyes, are tiny holes and very difficult to spot. The skin of a manatee is usually gray or brown and covered in short one- to two-inch hairs all over. Facial hairs, or whiskers, called vibrissae, cover the manatee's upper lip. They have large teeth at the back of their mouth, which are continually replaced throughout a manatee's life.

To breathe, manatees float to the surface, push their noses above the water, and take a deep breath, emitting a loud snort. Large flaps cover the nostrils when the animal is submerged. When active, manatees breathe about every three to five minutes;

asleep, they rise gradually from the bottom, floating slowly upward every ten to fifteen minutes for a somnolent breath.

Their principal daytime activity is eating. They are voracious herbivores, capable of consuming two hundred pounds of vegetation per day. When feeding on the bottom of the rivers they move their mouths as if vacuuming and chew vigorously with their strong jaws. They will also eat floating vegetation, using their flippers to guide the plants into their mouths.

Female manatees give birth to one calf every two to five years, after a gestation period of thirteen months. Calves weigh about eighty pounds at birth, and they stay with their mother for up to two years. Male manatees don't appear to have any role in caring for the calf. Imprinting through touch seems to be an important learning mechanism, and mother and calf often swim together, with the baby holding on to the mother's back with its tiny flippers. They may also communicate through sound, for divers have reported cooing sounds coming from mother and baby.

Worldwide, manatees face many threats. The Florida manatee has a population estimated at 1,200 to 1,500 and is one of the most endangered marine mammals in U.S. waters. Manatees have no natural predators. Cold weather, habitat destruction due to coastal development, and boats are the manatee's primary foes. Many adult manatees bear scars from collisions with boat propellers. While swimming slowly near the surface of the water, or bobbing up to breathe while asleep, they are unable to avoid fast-moving boats. Ironically, the collision scars are unique to each manatee, and thus are useful to researchers in identifying them and tracking their behavior. The Florida manatee is protected by the Marine Mammal Protection Act of 1972, the Endangered Species Act of 1973, and the Florida Manatee Sanctuary Act of 1978, but further research and strong conservation efforts are needed to save the manatee from extinction and enable them to flourish as they did hundreds of years ago.

Manatees can be seen at the following locations. Be sure to write or telephone in advance for viewing information and admission prices.

Blue Spring State Park

2100 West French Avenue

Orange City, FL 32763

Telephone: (904) 775-3663

Crystal River, Florida

For complete information, write to the Crystal River Chamber of Commerce

28 Northwest Hwy. 19

Crystal River, FL 34428

Telephone: (352) 795-3149

Homosassa Springs State Wildlife Park

4150 South Suncoast

Homosassa Springs, FL 34446

Telephone: (352) 628-2311

The Living Seas at Epcot Center

Walt Disney World

Lake Buena Vista, FL 32830

Telephone: (407) 824-2222

Lowry Park Zoo

7530 North Boulevard

Tampa, FL 33604

Telephone: (813) 935-8552

Manatee Springs State Park

11650 Northwest 115th Street

Chiefland, FL 32626

Telephone: (352) 493-6072

Miami Seaquarium

4400 Rickenbacker Causeway

Miami, FL 33149

Telephone: (305) 361-5705

Sea World of Florida

7007 Sea World Drive

Orlando, FL 32821

Telephone: (407) 363-2613

South Florida Museum

201 10th Street West

Bradenton, FL 34205

Telephone: (941) 746-4131

To learn more about manatees, contact the following organization:

Save the Manatee Club

500 N. Maitland Ave.

Maitland, Florida 32751

1-800-432-JOIN

(407) 539-0990

Web site: www.objectlinks.com/manatee